LIBRARY OF ART

PUBLISHER - DIRECTOR: GEORGE RAYAS

BYZANTINE ART IN GREECE

MOSAICS~ WALL PAINTINGS

General Editor

MANOLIS CHATZIDAKIS
Member of the Academy of Athens

"MELISSA" Publishing House

Translation: HELEN ZIGADA

Editorial Supervisor: LAMBRINI VAYENA-PAPAIOANNOU, philologist

Design: RACHEL MISDRACHI-CAPON

Photographs: MAKIS SKIADARESIS, STELIOS SKOPELITIS

Plans: YOTA ZACHOPOULOU, architect

Photo typesetting: FRAGOUDIS Bros

PATMOS

ELIAS KOLLIAS
Ephor of Byzantine Antiquities of Dodecanese

CONTENTS

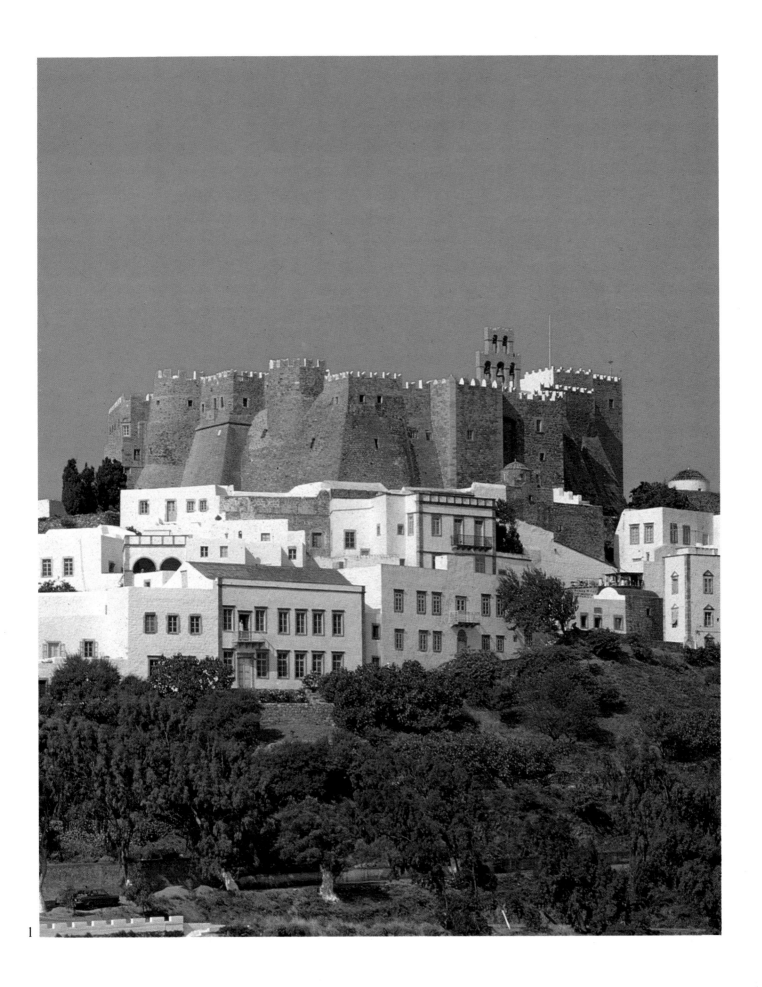

1

THE MONASTERY OF ST. JOHN THE THEOLOGIAN

The history of Patmos virtually begins in A.D. 1088, when in the month of April of that year Alexios I Comnenos, Emperor of Byzantium, ceded the island free of all taxation to Hosios Christodoulos of Latros (Asia Minor). The island of Patmos, "deserted and uncultivated, covered and made impassable by thorns and dry shrubs, and by reason of its aridity completely barren", had been known earlier to Christendom only as the place where St. John the Theologian had been exiled and where he probably wrote, at the end of the 1st century A.D., the Apocalypse and his Gospel. After February (or May) of A.D. 1089, the Blessed Christodoulos founded his monastery, the nucleus of a small state which included, in addition to Patmos, the neighbouring islets Lipsoi and Arkioi as well as large properties on the island of Leros.

The site where the monastery stands was apparently occupied in antiquity by a temple, perhaps of Artemis. The temple was replaced by an Early Christian basilica, and when this fell in ruins a small church was built on the site. We do not know what Hosios Christodoulos himself was able to do during the few years he spent on Patmos, for as he clearly states in his "secret testament": "I started with a castle, which I built as much as I could, leaving it incomplete...". It is doubtful whether Christodoulos was able to build even the Katholikon of the monastery, as may be inferred from his first biography written (sometime between 1118 and 1143) by John of Rhodes. This view has been accepted by A. Orlandos, who dates the Katholikon to *circa* 1090, but not by M. Chatzidakis. The work of Christodoulos was completed later, mainly in the 12th and 13th centuries. The Byzantine wall paintings of Patmos and other associated localities, such as the monastery's dependencies of the Hagioi Apostoloi on Kalymnos, of the Panagia Kastrinon on Kos and of Hagios Ioannes on Leros (unpublished), reflect a refined aesthetic standard. The monastery's abbots in the 12th and 13th centuries were men of culture and most had come from the upper social classes, while other members of the monastic community as well appear to have been of good education and descent. John, who became Metropolitan of Rhodes and wrote a biography of Hosios Christodoulos, had been at first a simple monk in the monastery of Patmos. The same was true of Athanasios, later Patriarch of Anti-

och, and of Theodosios, both of whom composed *encomia* to Hosios Christodoulos, the former in the third quarter and the latter in the end of the 12th century. Theodosios also wrote the biography of Hosios Leontios, Abbot of the Monastery of Patmos, Patriarch of Jerusalem, and probably donor of the wall paintings in the Chapel of the Holy Virgin.

The high standard of spiritual life in the monastery of Patmos is also reflected in the contents of its library. The first library was assembled by Christodoulos, who catalogued the books and bequeathed them to the monastery. Besides their monastic and religious activites, the Patmian monks were a learned community, maintaining close contact with the Capital of the Byzantine Empire. It is to be remembered that they lived on this "arid" rocky island, off the coast of Asia Minor, and that they were given every support by the state in order to hold that part of the Southeast Aegean against both the Turks and the Franks. This was, in fact, the true reason for the support accorded by Alexios I and his successors to the monastery of Patmos.

The quality and repertory of the monastery's wall paintings reveal its close association with the cultural centre of the Empire. In addition to the established traditional themes, however, the repertory of the iconography presents some remarkable peculiarities both in the choice and in the arrangement of the subjects. As an example we would mention the depiction of the miracles related to water — which also cleanses from sin — in the Chapel of the Holy Virgin; or, again, the association between two representations painted on the west wall of this chapel: the rare portrayal of the Hierarch as source of wisdom and the scene of the Healing of the Bent Woman (Fig. 9). The Bent Woman (above) may symbolize here the sinners who stoop in their preoccupation with earthly matters and are redeemed by the divine word as interpreted by the Hierarch (below) representing the Orthodox Church.

The frieze with the portraits of Patriarchs of Jerusalem (Fig. 19, 20, 22, 23) in the same chapel gives an indication of the donor's identity and sets forth the claims of the Empire on the Holy Lands, which were at the time under Frankish rule. Moreover, the representation of the Ecumenical Councils (Fig. 26) on the walls of the Refectory clearly confirms an adherence

to the Orthodox dogma as formulated and enforced by these Councils.

The Monastery of St. John the Theologian on Patmos, founded at the end of the 11th century by the Blessed Christodoulos of Latros, has partly preserved two ensembles of Byzantine wall paintings: the more complete murals in the Chapel of the Holy Virgin, and about half of the original paintings in the Refectory (Fig. 24). Some twelve years ago, remains of painted decoration were discovered in the Cave of the Apocalypse further down, north of Chora (Fig. 39). The Katholikon of the monastery was most probably decorated with wall paintings in the same period, and later painted over in successive layers. The similarity of style and technique noted in all these murals should be attributed to the provenance of the painters from the same artistic centre and to the painting of the works within a relatively short period of time.

Bibliography

Fr. Miklosich — I. Müller, *Acta et diplomata*, vol. 6, Vienna 1890.

A. Orlandos, Ἡ Ἀρχιτεκτονικὴ καὶ αἱ βυζαντιναὶ τοιχογραφίαι τῆς μονῆς τοῦ Θεολόγου Πάτμου, Athens 1970.

L. Hadermann-Misguish, "La peinture monumentale Tardo-Comnène et ses prolongements au XIIIe siècle", *Actes du XVe Congrès international d' études byzantines*, Athènes-Sept. 1976, vol. 1, Athens 1979, p. 264-265 and 270-271.

M. Chatzidakis, *Icons of Patmos*, Athens 1986.
Idem, «Μεσοβυζαντινὴ Τέχνη (1071-1204)», Ἱστορία τοῦ Ἑλληνικοῦ Ἔθνους, vol. Θ΄, Athens 1979, p. 408.

E. Vranousi, Βυζαντινὰ ἔγγραφα τῆς Μονῆς Πάτμου Α΄—Αὐτοκρατορικά, Athens 1980.

D. Mouriki, "Stylistic Trends in Monumental Painting of Greece during the Eleventh and Twelfth Centuries", *Dumbarton Oaks Papers*, vol. 34-35 (1980-1981), p. 116-117.

K. Skawran, *The Development of Middle Byzantine Fresco Painting in Greece*, Pretoria 1982, p. 176-178 and 179-180.

1. *Exterior view of the fortified Monastery of St. John the Theologian.*

2. *Ground-plan of the buildings where Byzantine wall paintings have been preserved.*

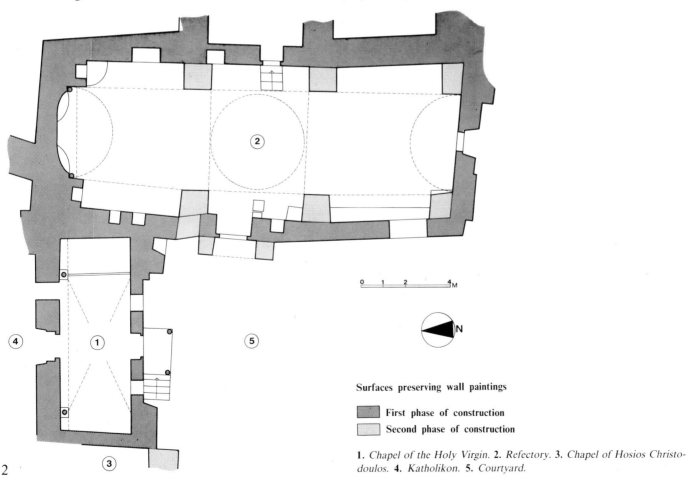

Surfaces preserving wall paintings

First phase of construction

Second phase of construction

1. *Chapel of the Holy Virgin.* 2. *Refectory.* 3. *Chapel of Hosios Christodoulos.* 4. *Katholikon.* 5. *Courtyard.*

2

THE CHAPEL OF THE HOLY VIRGIN

Architecture

In the 12th century, a single-naved chapel dedicated to the Holy Virgin was added to the south side of the Katholikon. Built in the space available between the Refectory and the Katholikon, the chapel is of somewhat irregular shape, measuring an average of 8.50 m. in length and 3.05 m. in width. The customary conch to the east is absent, because the Refectory that had been built earlier prevented its construction. The east side of the chapel, therefore, terminates in a flat wall (Fig. 2).

The south wall of the Katholikon was not used as the chapel's north wall — as would have been expected. Instead, a large, slightly pointed arch (in the middle) and two half arches (one on either side) were built in contact with the south wall of the Katholikon. The middle arch and one end of the half-arches spring from two short (1.12 m.) Early Christian columns with capitals. The other end of the half-arches abut against the respective short wall of the west and east sides (Fig. 3 and 14).

The west and east sections of the chapel are roofed with barrel-vaults. The middle part is covered with an oblong cross-vault with diagonal ribs, which fade gradually leaving a flat surface at the centre. The floor is paved with oblong marble slabs.

The sanctuary was separated by a marble templon, of which only traces are still visible on the floor. During one of the renovations, carried out in the early 17th century, the marble templon was replaced by the now surviving wooden screen, carved in the Cretan style in 1607.

Wall paintings

After the damage caused by the 1956 earthquake, the monastery was restored from its foundations by the Greek Archaeological Service in the period between 1957 and 1963. During restoration works the murals dating from 1745 — as recorded by the relevant inscription over the door giving access to the Katholikon — were removed from the wall (Fig. 6). The painting decoration of the 12th century was thus uncovered and is now visible over the greater part of the walls and ceiling of the chapel. Only a few of these early wall paintings had been either totally or partly ruined on the south wall and the ceiling.

The flat east wall of the sanctuary is divided into three horizontal zones. The lower one — which runs along all the walls — is painted with a *podea* (Plan, Π) imitating an ornate cloth embroidered with pseudo-Cufic designs, circles, quadrangles and horizontal lines. The middle zone (2.25 m. wide) is occupied by the representation of the Virgin and Child enthroned (Fig. 4, Plan no. 12) between the Archangels Michael and Gabriel (Fig. 5), and the upper zone by the scene of the Hospitality of Abraham (Fig. 8, Plan no. 11). The corresponding zone on the south wall of the sanctuary shows the Presentation of the Virgin in the Temple (Fig. 12, 13, Plan no. 13). The northern half of the vault — the greater part of which covers the sanctuary — is decorated with two scenes. One is now half-ruined and therefore difficult to interpret, the other shows Christ and the Samaritan Woman at Jacob's Well (John 4, 5-28) (Fig. 7, Plan no. 10). The southern half of this vault is painted with two miracle scenes, the Healing of the Paralytic (John 5, 2-9) (Plan no. 1) and the Healing of the Blind Man (John 9, 2-41) (Fig. 10, Plan no. 2). The flat surface formed at the centre of the chapel's ceiling, where the ribs of the cross-vault gradually fade away, has preserved a small part of a scene showing the Healing of the Ten Lepers (Luke 17, 11-14) (Plan no. 7) and a fragment of another unidentified scene (Plan no. 4). In the lower zone two Hierarchs are depicted co-officiating in the sanctuary (Plan no. 24-25). The south wall has preserved three figures of Hierarchs (a fourth one is no longer visible). Of the accompanying inscriptions recording their names only a badly damaged one has survived, reading: [St. Juvena]lius (422-458) or [St. Prau]lius (417-422) of Jerusalem (Plan no. 26). It is almost certain that the other figures also portray Patriarchs of Jerusalem (Fig. 22, 23, Plan no. 27-28).

The entire west wall is covered by just two scenes: the Healing of the Bent Woman, above (Luke 13, 10-17) (Fig. 9, Plan no. 29) and an Hierarch represented as source of wisdom, below (Plan no. 30). The first scene is not common to Byzantine hagiography. It occurs in Codices Gr. 510 and Gr. 74 of the National Library in Paris, at Monreale, and in Greece on the vault covering the prothesis of the Ai-Strategos Boularion in Mani. None the less, this miracle has been given special emphasis here.

The other scene is extensively damaged. From the Hierarch's lectern — now no longer visible —issue

rivers of wisdom from which clerics and laymen drink either in a lying or sitting position. This theme has its roots in Early Christian times, in the pictorial representation of Psalm 42-43, showing various animals, usually two confronting deer, drinking from a vessel. From the 10th century onwards the theme became associated with the teachings of St. John Chrysostom, the association having been apparently suggested by the hymnology to the Saint. In all probability, therefore, the Hierarch portrayed here is St. John Chrysostom, source of wisdom, although the possibility that the Hierarch may be St. Basil or St. Gregory should not be excluded. Any way, as far as we know, this scene appears for the first time in monumental painting on Patmos.

The north wall is decorated solely with full- or half-length portraits of Saints (Fig. 14, 15, 16). This arrangement may have been dictated by the architectural articulation of the walls. The large pointed arches and the presence of a door and window did not leave enough space for the painting of many-figured compositions. Above the ornamental lower band (*podea*), there is a wide zone, measuring 2.60 m. in height, with the portraits of four Hierarchs: St. Salustios of Jerusalem (486-494) (Fig. 20, Plan no. 58), St. Makarios (I) of Jerusalem (314-333) (Fig. 23, Plan no. 59), St. Elias (I) of Jerusalem (494-506) (Plan no. 62). The name of the last Hierarch is no longer extant, but his title "of Jerusalem" is legible (Plan no. 61).

The chapel, therefore, was decorated with the portraits of nine Patriarchs of Jerusalem in all, including James the Brother of Christ (Fig. 11, Plan no. 64), first Bishop of Jerusalem. His elderly figure, painted near the prothesis, is shown bowing reverently in worship to the Holy Virgin, portrayed on the east wall. Behind him is the frontal figure of St. Stephanos the Deacon (Plan no. 63). All Patriarchs wear *sticharia* (long tunics) with ornamental *cheiridia* (short sleeves) and over these *phailonia* (chasubles) and *omophoria* (episcopal stoles). They hold the Book of Gospels in the left hand, while the right makes either the sign of blessing or a serene gesture, or is simply placed on the Gospel Book. With the exception of James, they are all standing frontally and are connected in pairs by a sideward glance.

It is difficult to draw conclusions regarding the entire iconographical programme of the chapel, since an extensive part of the ceiling's wall paintings is now ruined. From the surviving representations, however, we may deduce that apart from the Presentation of the Virgin in the Temple and the Hospitality of Abra-

ham, the murals of the chapel must have depicted mainly Miracles of Christ. The Twelve Feast cycle and scenes from the Passion must have decorated the interior of the Katholikon. The scenes painted on the vault of the sanctuary — notably, the Presentation of the Virgin, the Hospitality of Abraham, the Healing of the Paralytic, the Healing of the Blind Man, Christ and the Samaritan Woman at the Well — have a symbolic association with this part of the church. The *Hermeneia* (*Guide of Painting*) recommends the holy bema as the proper place for painting the Presentation of the Virgin in the Temple. The Virgin, the "God-carrying temple", enters the Holy of Holies of the Temple of Jerusalem, which is associated with the heavenly bema of the spiritual world and with the holy bema of the church. The scene of the Hospitality of Abraham symbolizes the Holy Trinity, but it is also a eucharistic theme.

As far as the other three scenes are concerned, the question is to ascertain the reason for their presence in the holy bema rather than their common link. The common feature in all three scenes is the life-giving water, which heals (the Paralytic and the Blind Man) and quenches thirst (the Samaritan Woman). Since Early Christian times the liquid element has symbolized the Word of God, which emanates from the holy bema according to the Christian conception. This justifies the presence of the above scenes in the sanctuary. A similar arrangement occurs in the Katholikon of the Monastery of the Archangel Michael (dating from the first half of the 13th century) at Thari in Rhodes, where the western part of the sanctuary vault is painted with the Ascension and the eastern part, above the Holy Table, with a frieze which includes the Healing of the Paralytic, the Healing of the Blind Man and the scene of Christ and the Samaritan Woman at the Well.

The representations are, as a rule, simple. There is an overall tendency towards symmetry and rhythm and a predilection for frontal depiction. The Hospitality of Abraham is perfectly fitted within the arch of the east wall (Fig. 8). The middle angel, fully frontal, is painted on the vertical axis of the composition which starts from the crown of the arch and, passing through the angel's nose, chin and hand, ends at the middle leg of the table. This intentional symmetry is also noted in the triangle formed by the heads of the three angels, or by their hands raised in blessing, or again by the pairs of their feet. A similar effect of symmetry is observed in almost all the compositions which, however, are not always as closely knit as the

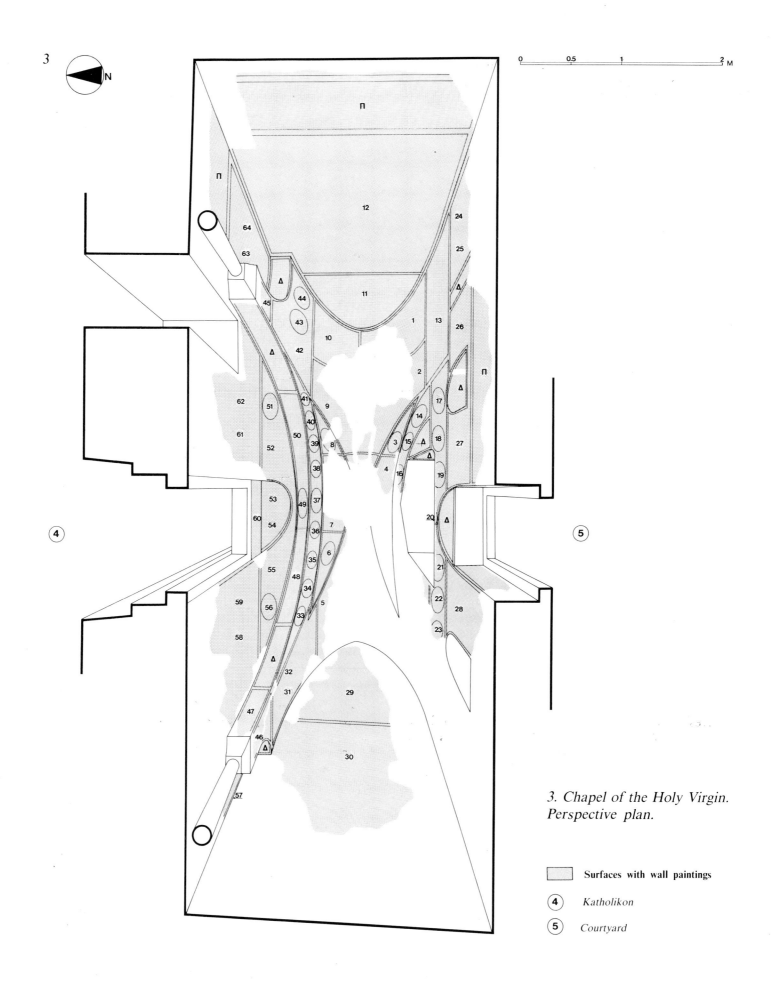

3
N

Π
Π
12
24
25
64
63
Δ
44
45
Δ
11
1
13
26
43
10
Δ
42
2
Π
62
51
41
9
17
Δ
40
14
61
50
39
8
3
15
Δ
18
27
52
38
4
16
Δ
53
37
19
49
60
54
36
7
20
Δ
55
6
21
48
35
59
56
5
22
28
34
23
58
33
Δ
32
29
31
47
30
46
Δ
57

*3. Chapel of the Holy Virgin.
Perspective plan.*

Surfaces with wall paintings

(4) *Katholikon*

(5) *Courtyard*

scene of the Hospitality. Triangular compositional arrangements are also encountered in the large-scale representation of the Virgin and Child enthroned with the two Archangels, on the east wall. In this painting a horizontal axis starts from the eyes of one of the Archangels, runs through the lower part of the neck of the Virgin and terminates at the eyes of the other Archangel. Another horizontal axis runs across the lower part of the neck of each Archangel and the eyes of the Christ Child.

The series of single portraits of Saints displays a similar marked tendency to symmetry and rhythm, especially in the elderly figures whose facial features — cheeks, ears, hair, beard etc. — are rendered almost in geometric forms. The garments, with their slightly agitated folds, sometimes cling to the body to accentuate a limb — for example, the knees and legs of the two lateral angels in the Hospitality of Abraham, and the right leg of the cleric who sits on the ground in the representation of the Hierarch as source of wisdom. The painter's inclination to rhythm and symmetry is likewise noticeable in the disposition of the paintings on the two side walls, the north and the south, where he depicted single figures and unrelated scenes (the Seven Youths in Ephesus etc.). The figures have almost all the same pose, differentiated by slight variations in the position of the hands and feet, in the holding of a Gospel Book or a cross etc. The frontality of the figures is relieved only by the sideward glance with which all portraits are painted (Fig. 17-22).

CHAPEL OF THE HOLY VIRGIN

1. *The Healing of the Paralytic.* **2.** *The Healing of the Blind Man.* **3.** *St. Epimachos.* **4.** *Unidentified scene.* **5.** *Unidentified scene.* **6.** *St. Arethas.* **7.** *The Healing of the Ten Lepers.* **8.** *Saint.* **9.** *Unidentified scene.* **10.** *Christ and the Samaritan Woman at the Well.* **11.** *The Hospitality of Abraham.* **12.** *The Virgin enthroned.* **13.** *The Presentation of the Virgin in the Temple.* **14.** *Saint.* **15.** *Saint.* **16.** *Saint.* **17.** *St. Arkadios.* **18.** *St. Xenophon.* **19.** *St. John.* **20.** *Fragment of a panel.* **21.** *St. Nathanael.* **22.** *St. Ioannikios.* **23.** *Saint.* **24.** *Hierarch.* **25.** *Hierarch.* **26.** *[Juvena] lius or [Prau] lius, Patriarch of Jerusalem.* **27.** *Patriarch of Jerusalem.* **28.** *Patriarch of Jerusalem.* **29.** *The Healing of the Bent Woman.* **30.** *Hierarch as source of wisdom.* **31.** *Hierarch.* **32.** *Hierarch.* **33.** *St. Stratonikios.* **34.** *St. Antoninos.* **35.** *St. Martinos.* **36.** *St. Dionysios.* **37.** *St. Exakoustidianos.* **38.** *St. Maximilianos.* **39.** *Saint.* **40.** *St. John.* **41.** *St. Hermylos.* **42.** *St. Gourias.* **43.** *St. Samonas.* **44.** *St. Abibos.* **45.** *St. Loukianos.* **46.** *Hierarch.* **47.** *Saint.* **48.** *Saint.* **49.** *St. Ismael.* **50.** *Saint.* **51.** *Deacon.* **52.** *St. Mokios.* **53.** *Saint.* **54.** *Saint.* **55.** *St. Nyphon.* **56.** *Deacon.* **57.** *St. Makarios of Jerusalem.* **58.** *St. Salustios of Jerusalem.* **59.** *St. Makarios of Jerusalem.* **60.** *Founder's inscription of 1745.* **61.** *Patriarch of Jerusalem.* **62.** *St. Elias of Jerusalem.* **63.** *St. Stephanos.* **64.** *St. James the Brother of Christ.* Π. *Podea.* Δ. *Decorative design.*

The manner in which all figures are modelled is uniform. Youthful ones are generally plump, their flesh rendered in warm colours, with red spots on the cheeks and greenish shades on the face (Fig. 5, 17 and 18). In elderly figures the facial features, hair and beard are often given geometric shapes and the wrinkled flesh is treated with yellow ochre, dark brown and greenish hues (Fig. 8, 11, 15, 16 and 19).

The whole decoration of the chapel appears to have been organized and supervised by one painter only. The head of Christ and of the Apostle in the scene of the Samaritan Woman at the Well, with the powerful modelling of the jaws, so unlike the other portraits in the chapel, may suggest the presence of another painter, whose style is strongly reminiscent of that of his fellow-artists who worked in the church of Hagioi Anargyroi at Kastoria. Everything else, however, the modelling of the uncovered parts of the body, the hair and beard, the drapery, the pose of the figures, the palette, even the ornate shaping of the ears and the patch of red colour on the cheeks, is the same throughout the entire painted decoration (Fig. 17, 18, 21 etc.).

The simple landscape of the wall paintings, their iconographic, figural and stylistic similarities with the mosaics at Monreale and with a number of mural paintings in the Hagioi Anargyroi and in Hagios Nikolaos tou Kasnitzi at Kastoria, suggest that the wall paintings in the Chapel of the Holy Virgin date from the last quarter of the 12th century. This dating is confirmed and perhaps given accuracy by the presence of the portraits of Patriarchs of Jerusalem, whose portrayal on the two lateral, north and south, walls of the chapel does not seem to have been accidental. In *circa* 1176, Leontios II (who died in 1190) became Patriarch of Jerusalem. Leontios had been Hegumen (Abbot) of the Monastery of Patmos since 1157/58 and appears to have retained the abbotship for a number of years, possibly until 1180. With the exception of a brief sojourn in Cyprus — on his way to Frankish-ruled Jerusalem where he tried to settle for a short period — he spent the remaining years in Constantinople, from where he helped the Patmian monks in many ways.

The series, therefore, of the portrayed Patriarchs of Jerusalem may suggest a donation and even some supervision by Leontios of the painting of the Chapel of the Holy Virgin. Indeed, the murals may have been painted while Leontios was Patriarch of Jerusalem and at the same time Hegumen of the Monastery of Patmos, i.e. in 1176-1180.

4　5

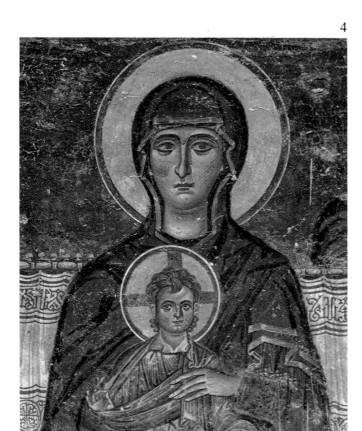 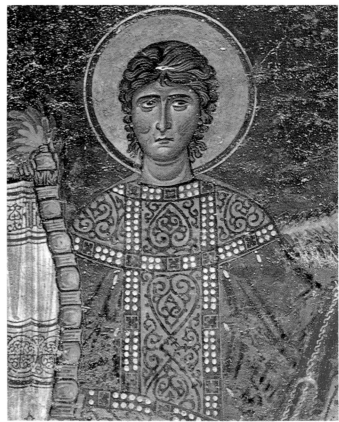

6

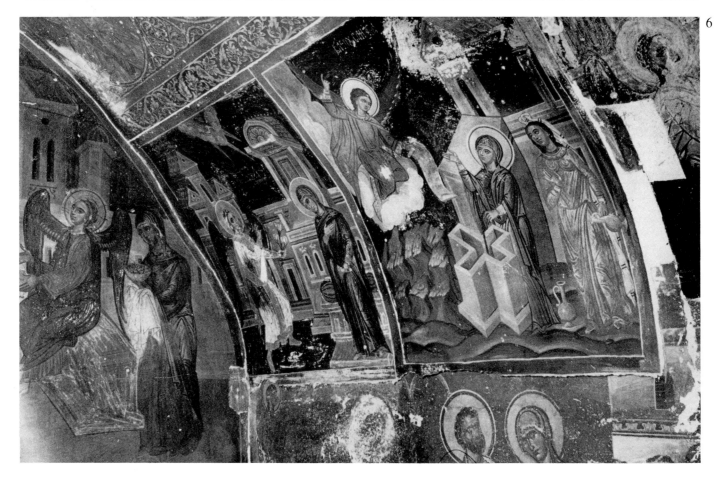

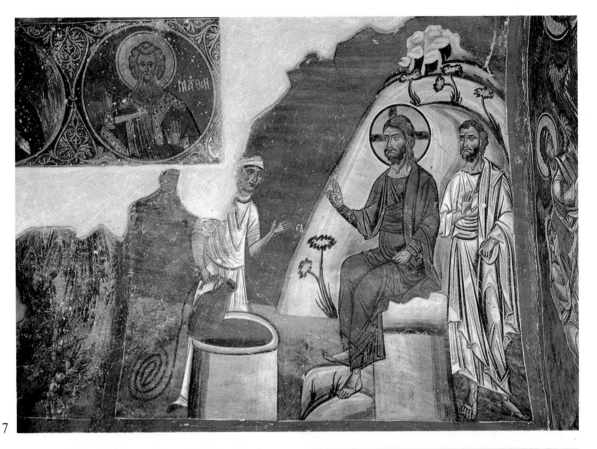

7

8

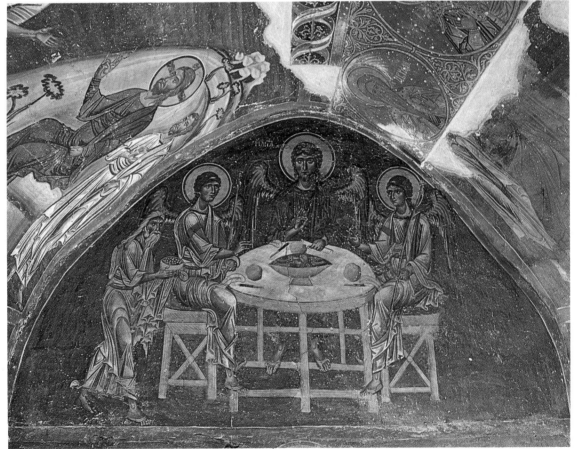

9

10

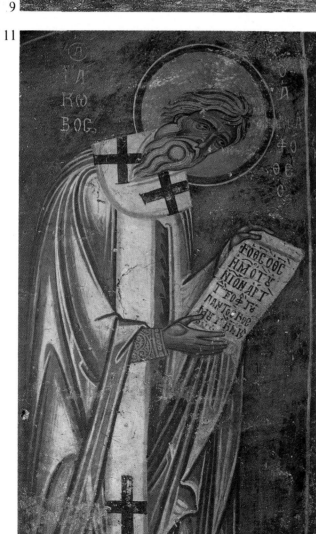

11

4. Chapel of the Holy Virgin. The Virgin and Child enthroned (detail).

5. Chapel of the Holy Virgin. Archangel (detail of the same composition as Fig. 4).

6. Chapel of the Holy Virgin. The Annunciation and the Annunciation at the Well, wall paintings of 1745, which covered the earlier representation of the Healing of the Blind Man (Fig. 10).

7. Chapel of the Holy Virgin. Christ and the Samaritan Woman at the Well.

8. Chapel of the Holy Virgin. The Hospitality of Abraham.

9. Chapel of the Holy Virgin. The Healing of the Bent Woman.

10. Chapel of the Holy Virgin. The Healing of the Blind Man (fragment).

11. Chapel of the Holy Virgin. St. James the Brother of Christ.

12. Chapel of the Holy Virgin. The Presentation of the Virgin in the Temple (detail).

13. Chapel of the Holy Virgin. The Friends of the Virgin (detail of the same composition as Fig. 12).

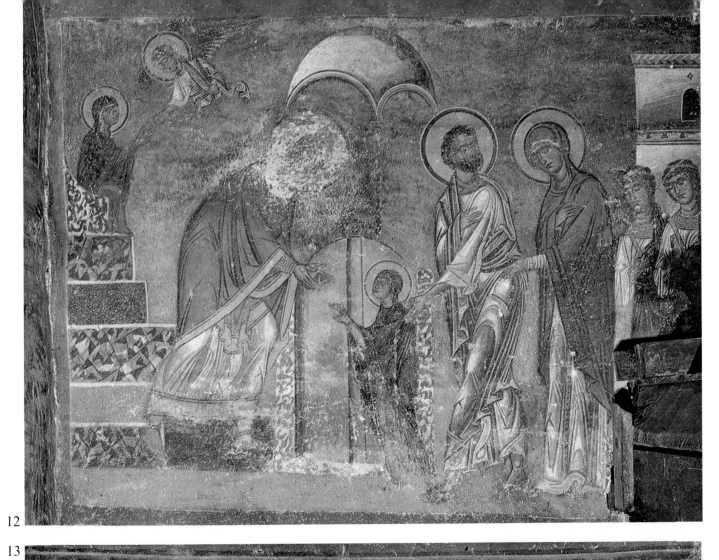

12

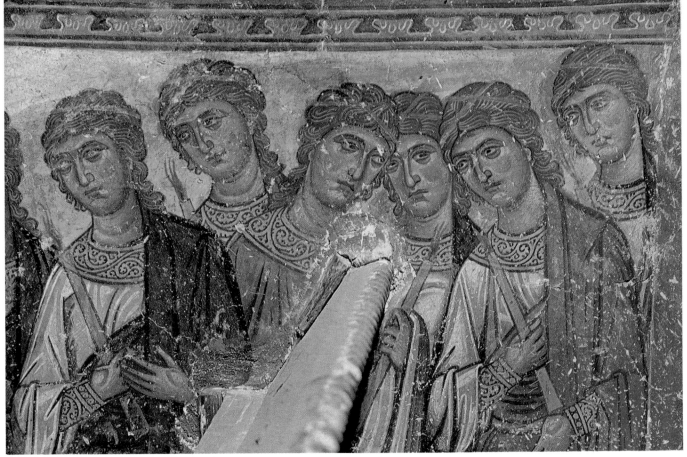

13

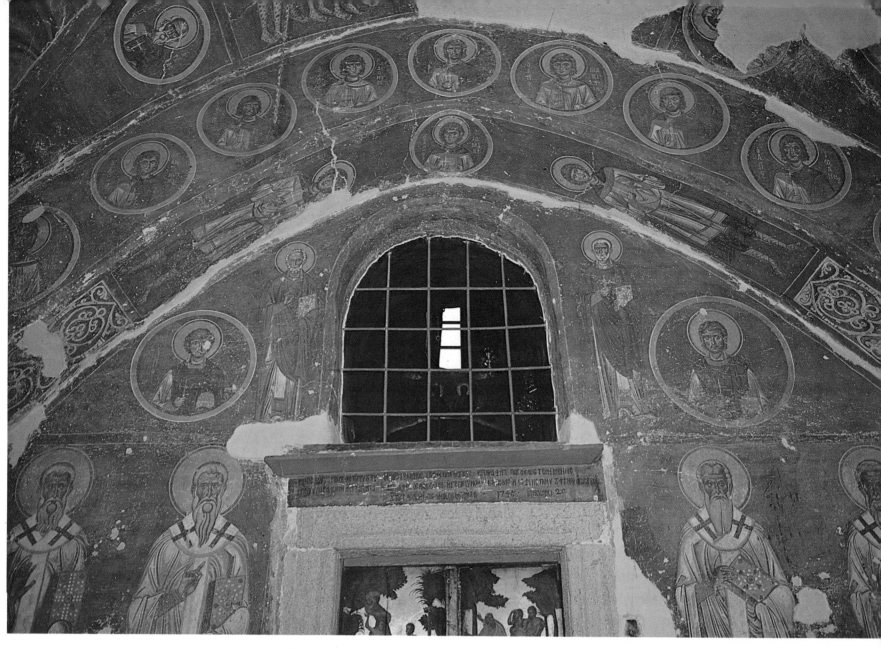

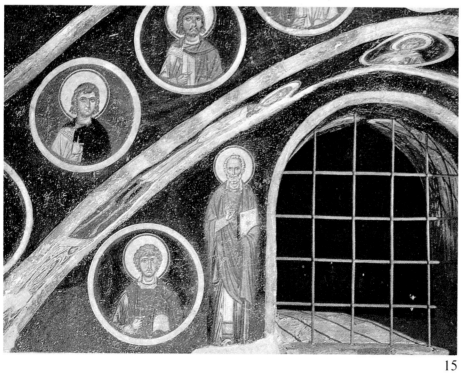

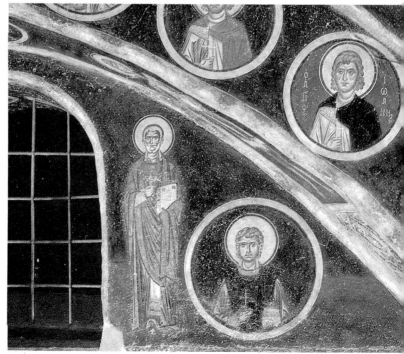

15 16

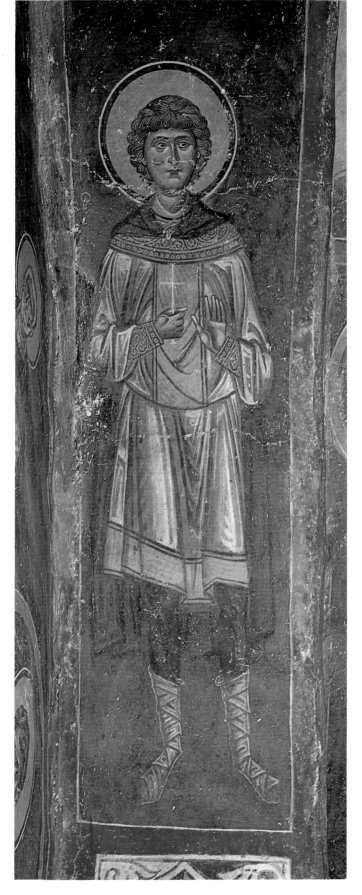

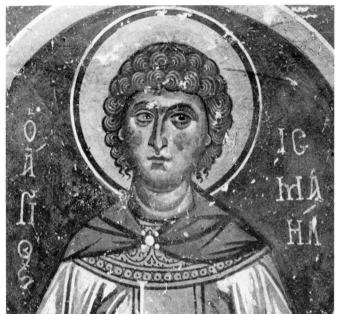

14. *Chapel of the Holy Virgin. General view of the north wall, including the arch and part of the ceiling.*

15, 16. *Chapel of the Holy Virgin. Two sections of the north wall.*

17. *Chapel of the Holy Virgin. Anonymous young martyr painted on the soffit of the arch.*

18. *Chapel of the Holy Virgin. St. Ismael.*

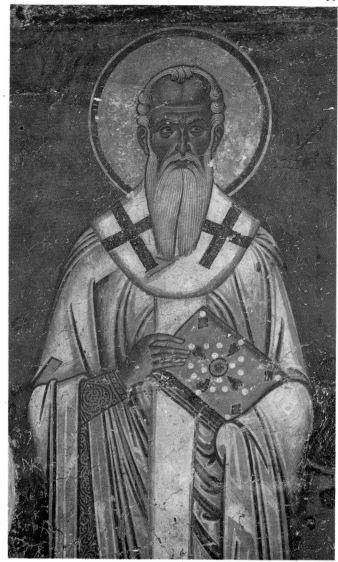

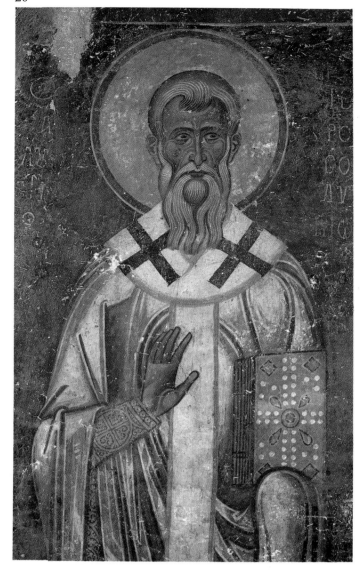

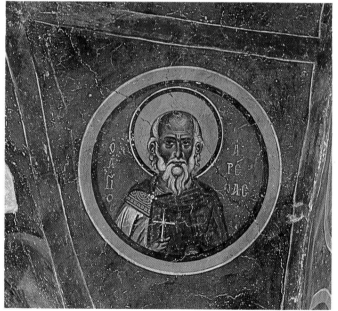

19. *Chapel of the Holy Virgin. Anonymous Patriarch of Jerusalem.*

20. *Chapel of the Holy Virgin. St. Salustios of Jerusalem.*

21. *Chapel of the Holy Virgin. St. Arethas.*

22. *Chapel of the Holy Virgin. Anonymous Patriarch of Jerusalem.*

23. *Chapel of the Holy Vigin. St. Makarios of Jerusalem.*

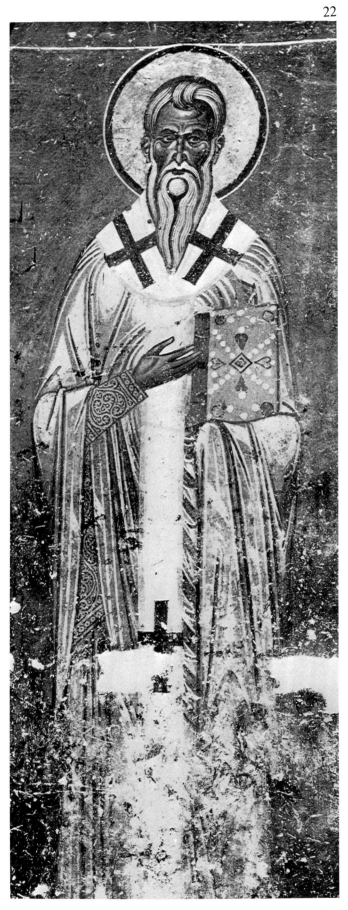
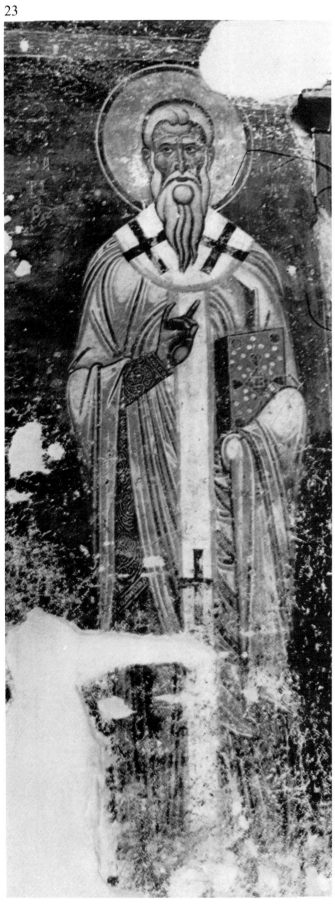

THE REFECTORY

Architecture

The Refectory of the monastic complex, a long and narrow building measuring 16.60 m. in length and 6.45 m. in width, was built in the early decades of the 12th century. It stands to the SE of the Katholikon and adjoins the east wall of the Chapel of the Holy Virgin. The walls, constructed with local stones of irregular shape, have no exterior decoration. Originally the Refectory was perhaps covered with a wooden roof, which was removed for unknown reasons, possibly in the early 13th century, and replaced by a domed roof. The dome, which rises in the middle, rests on two broad arches to the E and W and on two slightly pointed vaults along the N-S axis. These are supported by lateral blind arches (Fig. 2 and 24) which have preserved parts of the first layer of wall paintings (Plan nos. α-στ and Fig. 29).

Painting

The Refectory appears to have been entirely covered with wall paintings during both the first and the second phase of construction. The wall paintings preserved from the second phase extend over the greater part of the west wall and a section of the north wall, whereas a few traces are visible on the east wall (see plan Fig. 24).

First phase. Paintings of the earlier layer have been preserved only on the tympanum of the north blind arch of the west side. The decoration of the tympanum is divided into two horizontal zones. The lower includes, from left to right, the now half-length figures of the Saints Euthymios (Fig. 29, Plan no. α), Chariton (Fig. 37, Plan no. β), Hilarion (Plan no. γ), and of another Saint (Plan no. δ) whose name has been covered by the arch of later date. These powerful and expressive figures show a marked resemblance to the Saints Salustios (Fig. 20), Mokios and Nyphon portrayed in the Chapel of the Holy Virgin. The fourth Saint has a slight squint, like that of the Virgin portrayed in the chapel. Above these saintly figures, two scenes have been partly preserved: to the left, the Appearance of Christ to the Disciples by the sea of Tiberias (Fig. 29, Plan no. ε) and the Miraculous Draught of Fish (10th Matutinal Gospel Reading, John 21, 1-6) — of this representation only the boat riding the waves and some of the Apostles rowing are visible; to the right, the Multiplication of the Loaves (Plan no.

στ) — of which three loaves and four fishes can be seen on a table.

The surviving part of the first layer of wall paintings in the Refectory does not permit any suggestions about the iconographic programme. Regarding its date and the associated artistic trend, it presents a close resemblance, particularly in the saintly portraits, with the murals in the Chapel of the Holy Virgin, and this places it near the end of the 12th century. A. Orlandos assigns the wall paintings of the first layer to the beginning of the 13th century.

Second phase. Of the second layer of mural decoration, painted when the Refectory was covered with a dome and vaults, almost half has been preserved, so that the iconographic programme is only partly known. What has survived to this day may be divided into four iconographic cycles: a eucharistic cycle, a cycle related to the Passion and Death of Christ, a dogmatic cycle with representations of Ecumenical Councils, and a cycle comprising figures of great hermit Saints and scenes from their lives, to serve as models for the Patmian monks.

The first cycle, the eucharistic, extends over the north part of the west wall and the adjacent north wall. The scenes include: the Appearance of Christ to the Disciples by the sea of Tiberias (Fig. 29, Plan no. 1), the Multiplication of the Loaves (Plan no. 2), the *Metalepsis*, i.e. Christ Giving the Wine to the Apostles (Fig. 36, Plan no. 3) and the *Metadosis*, i.e. Christ Giving the Bread to the Apostles (Fig. 34, Plan no. 4) and the scene of Abraham Welcoming the Three Angels (Fig. 38, Plan no. 5).

In some of these scenes the eucharistic meaning is quite obvious while in others it can be inferred. There can be no doubt, of course, about the *Metalepsis* and the *Metadosis*. The scene of Christ Appearing to His Disciples belongs to the cycle of events after the Resurrection, but in this case it has also a eucharistic meaning accented by the presence of the fish and bread — old symbols of Christ — at the feet of Jesus. The Multiplication of Loaves has been associated with the Holy Communion since the early representations in the catacombs. The last scene, of Abraham Welcoming the Three Angels, belongs to the cycle of the Old Testament which includes the Hospitality of Abraham, symbolizing the Holy Trinity as well as the Holy Eucharist (see Chapel of the Holy Virgin).

The arrangement does not adhere strictly to the sequence of historical events. This eucharistic cycle is

followed by some scenes from the second cycle, related to the Passion and Death of Christ — notably, Jesus Praying in the Garden of Gethsemane (Fig. 27, Plan no. 6), the Betrayal of Judas (Fig. 28, Plan no. 7) and Christ Washing the Feet of His Disciples (Plan no. 8), all episodes that occurred before the Crucifixion.

The tympanum and soffit of the great arch in the middle of the west wall — below the dome — where the entrance is situated, are decorated with seven scenes from the Passion of Christ and one from the events after the Resurrection. The greater part of the tympanum is occupied by the agitated many-figured composition of the Crucifixion (Fig. 30, Plan no. 9). Above this, the lower part of another scene is visible, possibly representing Christ Being Led to the Cross (*Helkomenos*) (Plan no. 10). On the right side of the soffit the following scenes can be seen, starting from above: Christ before Annas and Caiaphas (Plan no. 11), Peter's Denial (Plan no. 12) and the scene from the first Matutinal Gospel where Christ appeared to the Apostles after His Resurrection and said unto them: "*Go ye and teach all nations...*" (Plan no. 13). On the left side of the soffit are painted: the Preparation of the Cross (Plan no. 14), the Distribution of the Garments (Plan no. 15) and the Descent from the Cross (Fig. 31, Plan no. 16).

On the west half of the south vault of the Refectory the paintings are arranged in two zones. The lower contains three scenes: the Lamentation for Christ (Fig. 26, Plan no. 17), the Myrrh-bearing Women at the Sepulchre (Fig. 26, Plan no. 18) and the Descent into Hell *(Anastasis)* (Plan no. 19). The upper zone is painted with the dogmatic cycle comprising three of the seven Ecumenical Councils (Fig. 25, 26), notably the Second (Plan no. 20), the Fourth (Plan no. 21) and the Sixth (Plan no. 22), i.e. those with an even number. The other four Synods may have been painted on the east half of this vault.

The decoration on the tympanum and soffit of the south blind arch of the west wall includes scenes from the fourth cycle, that related to the lives of major hermit Saints (Orlandos, p. 181, assigns these paintings to the first layer). Except for one, the scenes are difficult to interpret from the iconographical point of view. The painting on the left part of the tympanum shows the Death of the Righteous Man (Plan no. 23). The half-ruined scene on the left part of the soffit may have represented the Death of the Sinner (Fig. 26 lower left, Plan no. 24). Both paintings depict visions attributed to St. Euthymios. The right part of the same tympanum and soffit is painted with two visionary scenes related to death (Plan nos. 25-26), but unidentified as far as the iconographic subject is concerned. To this fourth cycle also belong the Saints portrayed on the north half of the west wall, on the tympanum and the soffit: St. Dionysios the Areopagite (Fig. 33, Plan no. 27), St. Cyprianos (Fig. 32, Plan no. 28), St. Amphilochios (Plan no. 29) and St. Gregory the Acragantine (Plan no. 30).

It is quite obvious that the wall paintings of the second layer in the Refectory have not been executed by a single atelier. The northern part, as far as the arch supporting the dome on the west side, was painted by one atelier, the rest by another.

The painter of the northern part worked in accordance with the artistic trends of the late 12th century. He displays a tendency to rhythm, which acquires an almost dance-like quality in the scene of Abraham Welcoming the Three Angels and an ornamental effect in the drawing of bodies and draperies. The right leg of Judas in the Betrayal (Fig. 28) and the right leg of the Apostle Andrew in the *Metalepsis* (Fig. 36) are most powerfully rendered, as the tightly clinging garment forms swirls and sinewy lines. In the scene of the Prayer in the Garden of Gethsemane, the hair of the Disciple sleeping with his head resting on his knees looks rather like a jelly-fish or a flower (Fig. 27). In the Betrayal, the half-turned figure of Judas is skilfully painted (Fig. 28). This rendering is not a novel feature in Byzantine art and is encountered in works of the second half of the 12th century, e.g. in the Hagioi Anargyroi at Kastoria, at Kurbinovo and elsewhere. On the whole the compositions do not display the serenity and unaffected simplicity of the paintings in the Chapel of the Virgin, but are many-figured and agitated.

Third phase. The wall paintings on the west arch supporting the dome and in the southern part of the Refectory were executed by an atelier which seems to have been closer to the artistic current of the 13th century. Faces are portrayed more freely and, at times, with a marked dramatic quality. The many-figured composition of the Crucifixion has almost none of the severity displayed by earlier representations of the subject. The culminating points of the scene are the Fainting of the Virgin and the Lamentation of the Angels (Fig. 30). This scene from the Passion cycle is the focal point of the surrounding group of scenes painted on the soffit and the tympanum of the arch, and it heightens the dramatic effect. Some of the scenes, such as the Crucifixion, the Distribution of the

Garments, the Lamentation for Christ and the Descent into Hell, not only contain many figures and details but are also accompanied by excerpts from liturgical texts, written on unrolled scrolls held by their authors who are portrayed aside full-length. The representations of the Ecumenical Councils are similarly accompanied by extensive texts densely written on scrolls held unrolled by a great number of Hierarchs (Fig. 26). The texts lend the scenes a pronounced dogmatic character. The great number of figures, the intense dramatic quality which pervades the scenes, and the stylistic features already mentioned, assign these wall paintings to the third quarter of the 13th century.

There are no significant differences of opinion regarding the dating of the wall paintings of Patmos.

To summarize: Chapel of the Virgin: Last decade of the 12th century according to Orlandos, 1176-1180 according to Kollias. Refectory. First phase: Contemporary with the Chapel murals. Second phase (northern part of west wall): Early decades of the 13th century according to Orlandos, *circa* 1200 according to Chatzidakis, end of 13th century according to Kollias. Third phase (southern part of west wall): According to Orlandos, second half of 13th century, with the murals of the blind arch assigned to the first phase; according to Kollias, all murals assignable to the third quarter of the 13th century.

24. Refectory. Plan showing the position of wall paintings.

25. Refectory. Part of the west wall and arch, and part of the south vault.

REFECTORY

First layer. α. *St. Eutymios.* **β.** *St. Chariton.* **γ.** *St. Hilarion.* **δ.** *Saint.* **ε.** *The Appearance of Christ to the Disciples by the Sea of Tiberias.* **στ.** *The Multiplication of the Loaves.* **Second layer. 1.** *The Appearance of Christ to the Disciples by the Sea of Tiberias.* **2.** *The Multiplication of the Loaves.* **3.** *The Metalepsis of the Apostles.* **4.** *The Metadosis of the Apostles.* **5.** *Abraham Welcoming the Angels.* **6.** *The Prayer in the Garden of Gethsemane.* **7.** *The Betrayal of Judas.* **8.** *Christ Washing the Feet of His Disciples.* **9.** *The Crucifixion.* **10.** *Christ Being Led to the Cross (Helkomenos).* **11.** *Christ before Annas and Caiaphas.* **12.** *Peter's Denial.* **13.** *"Go ye and teach all nations".* **14.** *The Preparation of the Cross.* **15.** *The Distribution of the Garments.* **16.** *The Descent from the Cross.* **17.** *The Lamentation for Christ.* **18.** *The Myrrh-bearing Women at the Sepulchre.* **19.** *The Descent into Hell (Anastasis).* **20.** *The Second Ecumenical Council.* **21.** *The Fourth Ecumenical Council.* **22.** *The Sixth Ecumenical Council.* **23.** *The Death of the Righteous Man.* **24.** *The Death of the Sinner (?).* **25.** *Visionary scene.* **26.** *Monk and inscription.* **27.** *St. Dionysios the Areopagite.* **28.** *St. Cyprianos.* **29.** *St. Amphilochios.* **30.** *St. Gregory the Acragantine.* **Δ.** *Decorative design.*

24

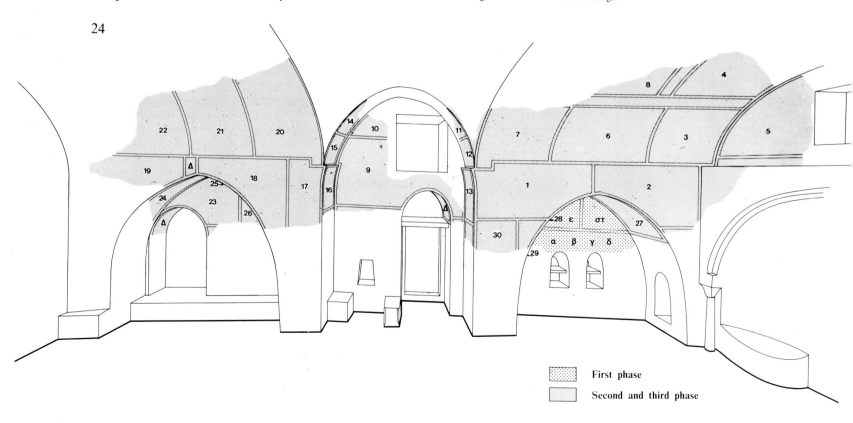

First phase

Second and third phase

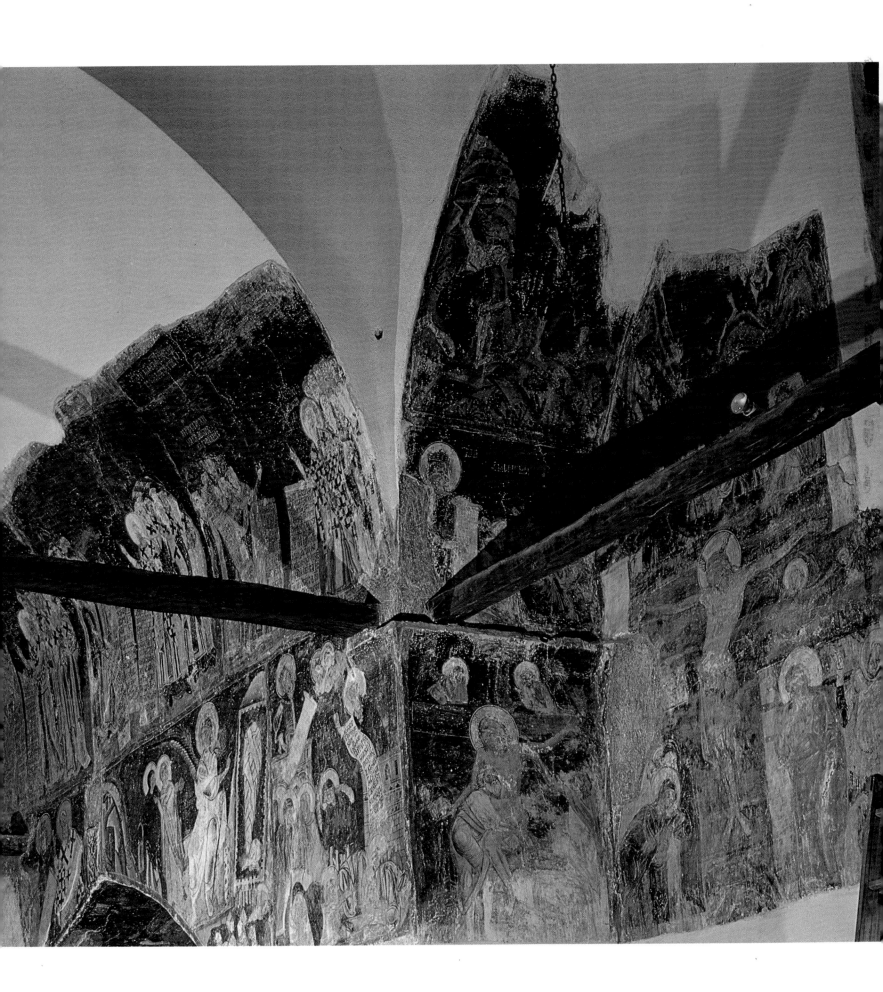

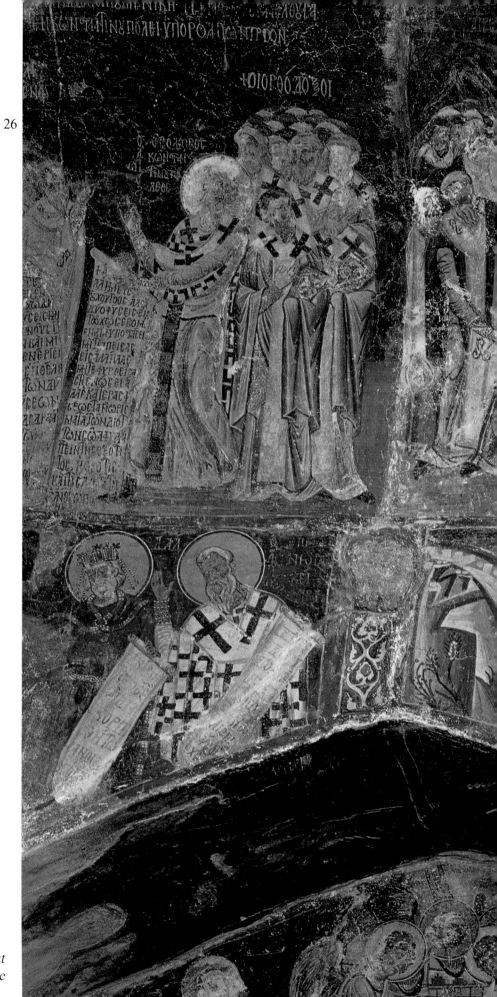

26. *Refectory. South part of the west wall of the south vault, and part of the south blind arch.*

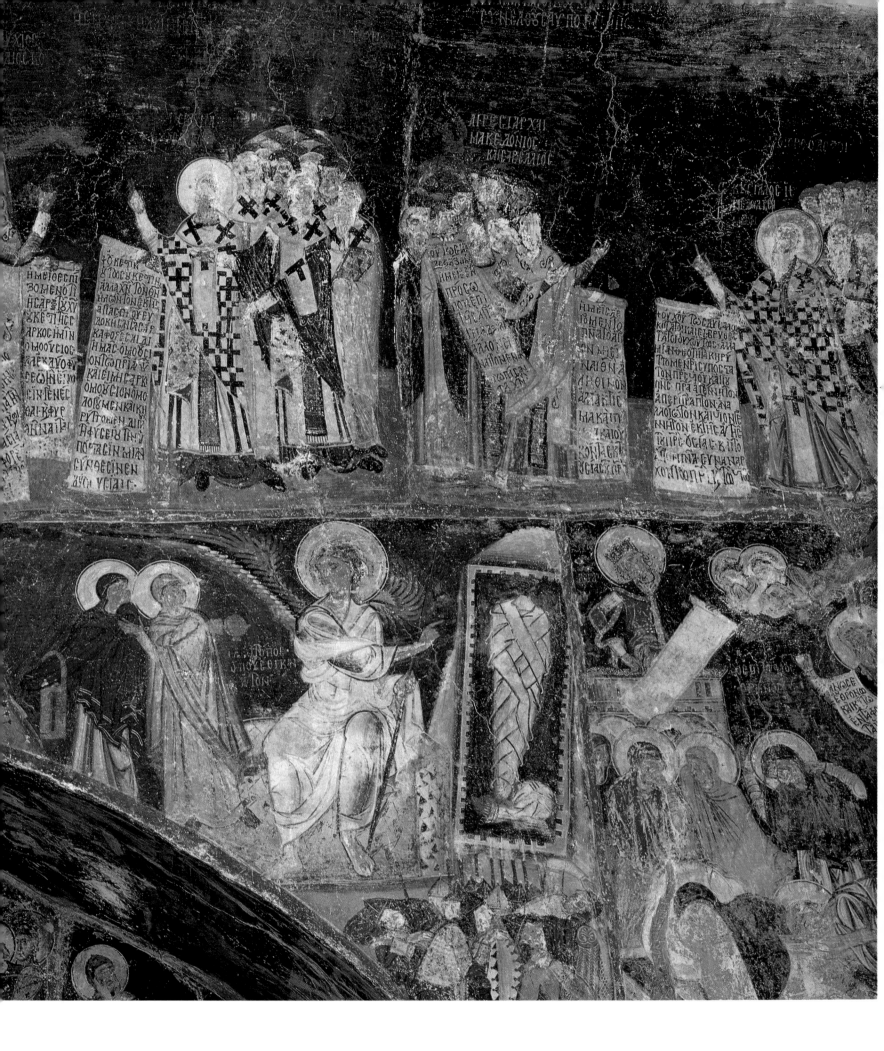

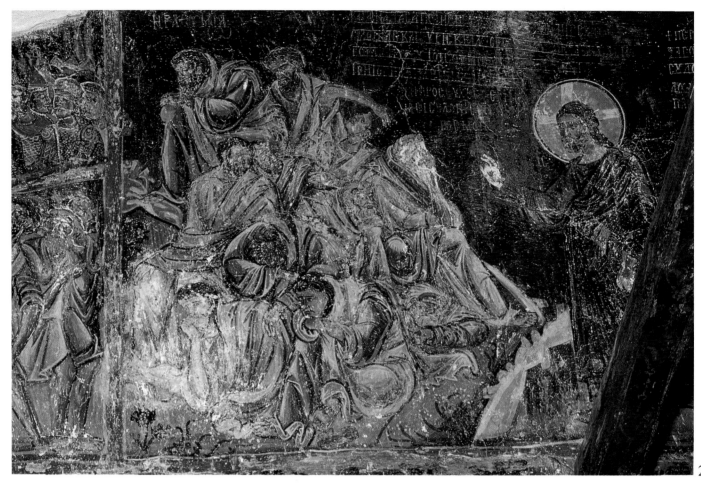

27

28

30 *E. KOLLIAS*

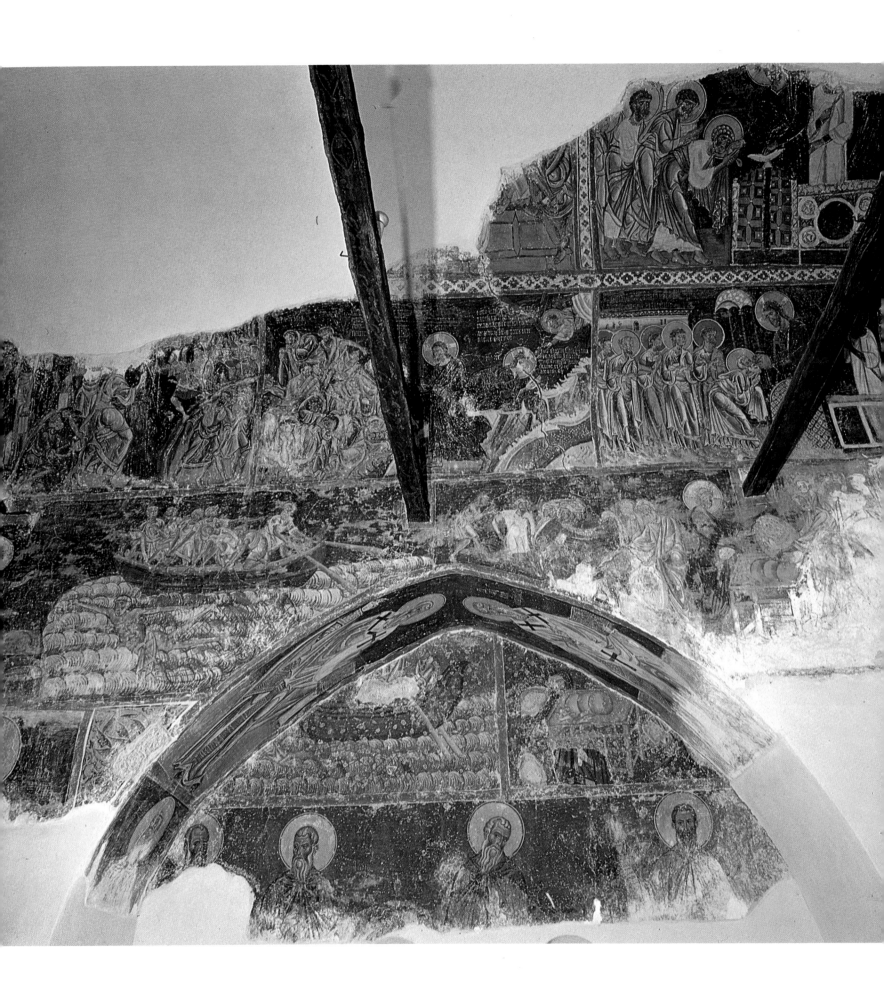

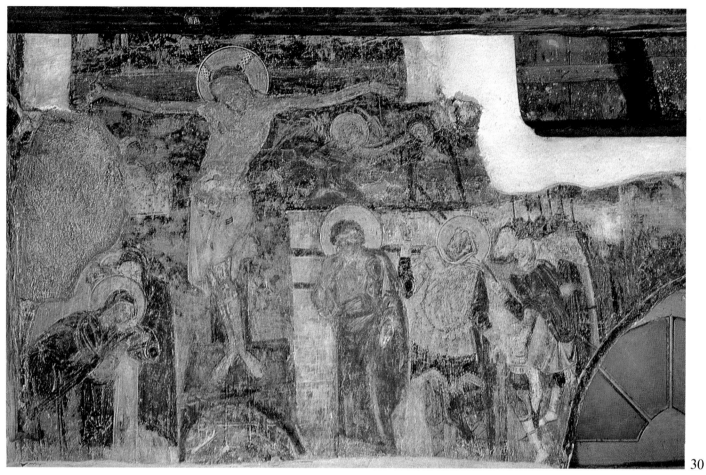

30

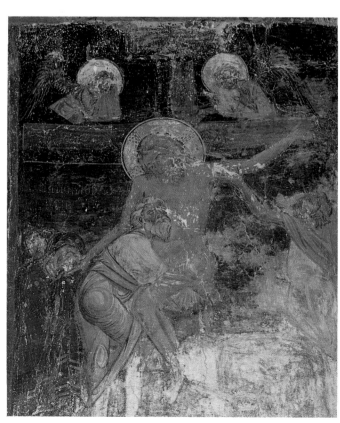

31

27. Refectory. North vault. The Disciples sitting idly, detail of the Prayer in the Garden of Gethsemane (see Fig. 29).

28. Refectory. North wall. The Betrayal of Judas (see Fig. 29).

29. Refectory. North part of the west vault, wall and blind arch.

30. Refectory. The Crucifixion (see Fig. 25).

31. Refectory. The Descent from the Cross.

32. Refectory. St. Cyprianos.

33. Refectory. St. Dionysios the Areopagite.

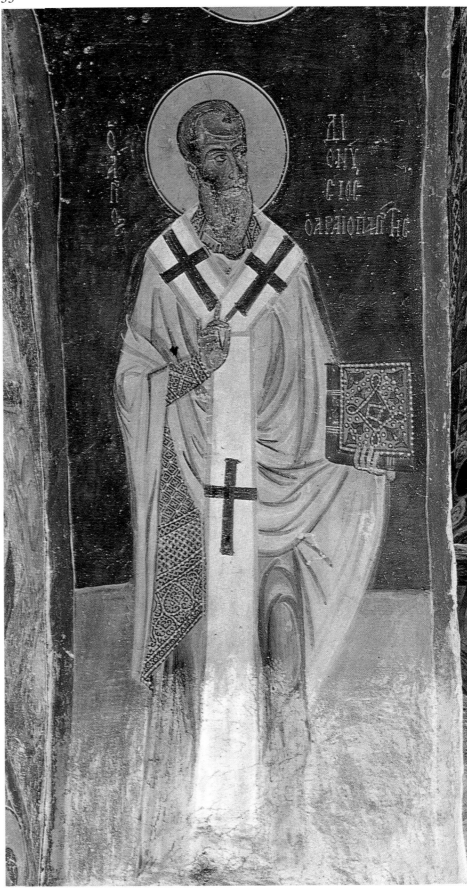

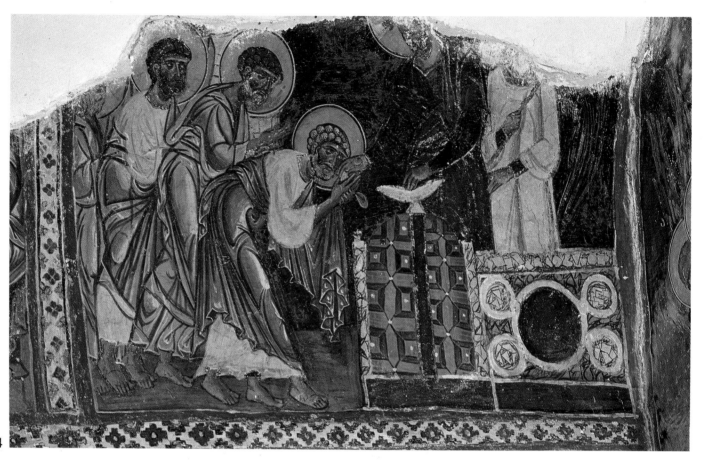

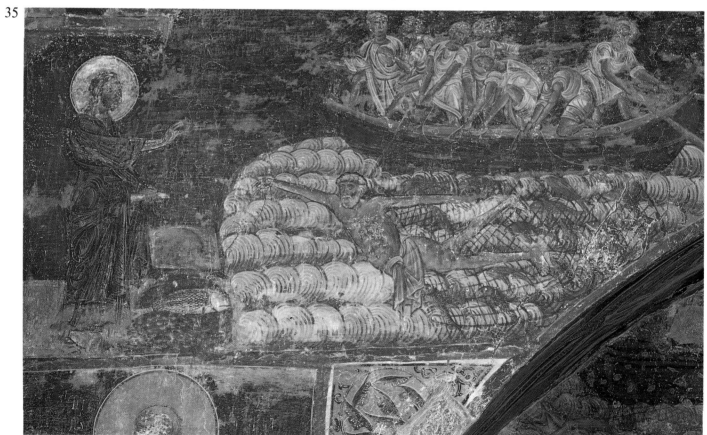

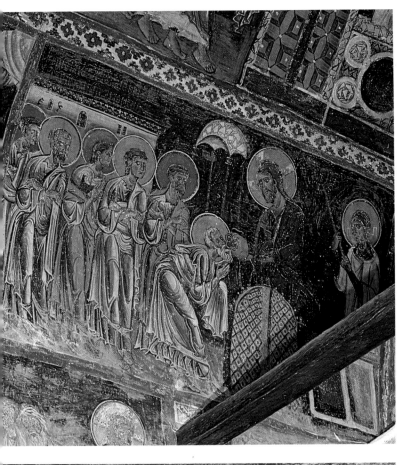

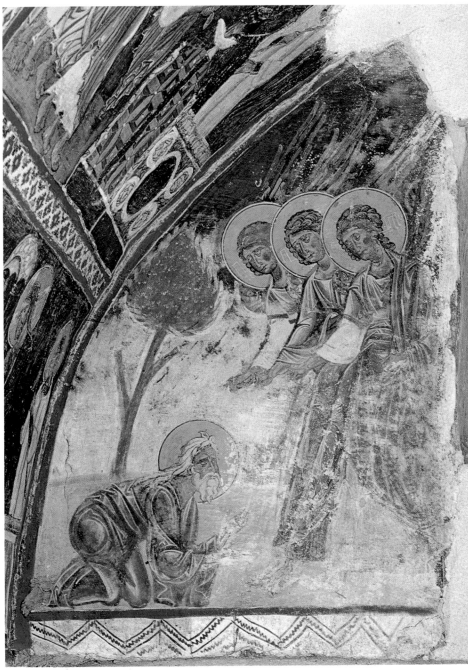

38

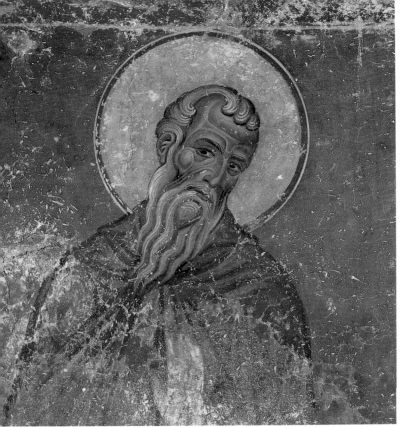

34. Refectory. The Metadosis, from the Communion of the Apostles.

35. Refectory. The Appearance of Christ to the Disciples by the Sea of Tiberias.

36. Refectory. The Metalepsis, from the Communion of the Apostles.

37. Refectory. St. Hilarion (see Fig. 29).

38. Refectory. Abraham Welcoming the Three Angels.

THE CAVE OF THE APOCALYPSE

Tradition has it that in this cave St. John the Theologian dictated to his disciple Prochoros the Apocalypse and his Gospel. To this centre of worship were later added clusters of cells, little churches, passageways, cellars etc. With the passing of time these structures have formed a compound of intricate interior arrangement and of attractive exterior appearance, which now stands, all-white, half-way up the road leading from the harbour to Chora.

The core of the religious compound is a bipartite church. The northern part, single-naved with vaulted roof, is dedicated to St. Anne. The southern part, i.e. the cave proper, is consecrated to St. John the Theologian. Judging from traces of the first layer of wall paintings, the earliest arrangement seems to have been effected by the monks who succeeded Hosios Christodoulos, in the first half of the 12th century. According to popular tradition, Hosios Christodoulos was the founder of this construction, as he was of other monuments on Patmos. However, as his hasty departure from the island left him no time to complete even the building of the monastery, he may not have had the time to do much for the site of the cave either.

The wall paintings

In 1973, some wall paintings were discovered accidentally under the coating of whitewash in the holy bema of the cave proper. When the natural cave was originally tranformed into a place of worship, a wall was constructed along the eastern side, with a small conch at either (north and south) end to serve as the prothesis and the diakonikon respectively. It is not known whether this wall included a large central conch, or whether the Holy Table was simply placed before the straight wall. In any case, the present apse did not exist in this initial phase. Extensive parts of two successive layers of earlier wall paintings were destroyed on either side of the central conch, when this was either constructed for the first time or enlarged towards the end of the 16th century. In the author's opinion, the first layer of mural decoration probably belongs to the initial phase of construction. Today, to the right of the central apse we can see a cross painted in light red, with stylized tendrils stemming from the base and the initial letters Φ(ῶς) Χ(ριστοῦ) Φ(αίνει) Π(ᾶσι) ("The Light of Christ Lights All") written between the arms (Fig. 39).

At a later period, the entire east wall of the sanctuary was covered with a mural decoration, part of which has survived in a considerably damaged state. To the right of the central apse, a large-scale painting depicts the event that had consecrated this place: standing in the midst of a mountainous landscape, St. John the Theologian listens to the Word of God and dictates it to his disciple Prochoros. The lower section of the representation is now ruined and the paint has flaked off from various parts of Prochoros' hair, body and garments. Above the head of the Evangelist an inscription reads: Ο Α(ΓΙΟΣ) ΙΩ(ΑΝΝΗΣ) Ο ΘΕΟΛΟΓΟΣ.

When painting the scene of the Vision of St. John in the very cave where according to tradition the event took place, the painter made no attempt to represent the actual surroundings. Instead, he placed the figures in an open air scenery, in accordance with an established iconographical model (Fig. 39.).

Of the two portraits of Hierarchs painted on the small conch of the prothesis, the one to the right has been preserved and shows the half-length figure of St. Basil holding with both hands a closed Gospel Book. To the right of the central conch can be seen a fragment of the nimbus of St. Nicholas with the Saint's name next to it — the painting was destroyed either when the central conch was constructed or when it was enlarged. At the south end of the sanctuary, humidity has destroyed the half-length figure of an unknown holy man painted within the small conch of the diakonikon. Similarly damaged are two half-length figures of martyrs holding a cross, the one above the conch of the diakonikon, the other to the right. All the wall paintings are now full of Frankish names of various epochs, scratched around the figures of the Saints, perhaps as "invocations" by solitary West European pilgrims, or by Frankish assailants who set foot on Patmos quite often from the 12th century onwards, pillaging the island and exacting ransom from the monastery. Some Greek names have also been scratched at times on the wall paintings.

The way in which the painter has treated the face of each of the two best-preserved Saints, notably St. John the Theologian and St. Basil, presents a striking contrast. Both figures are elderly but their facial features are rendered quite differently. The forehead and cheeks of St. Basil are marked with deep wrinkles forming almost geometric patterns. By contrast, the elderly face of St. John the Theologian has been ren-

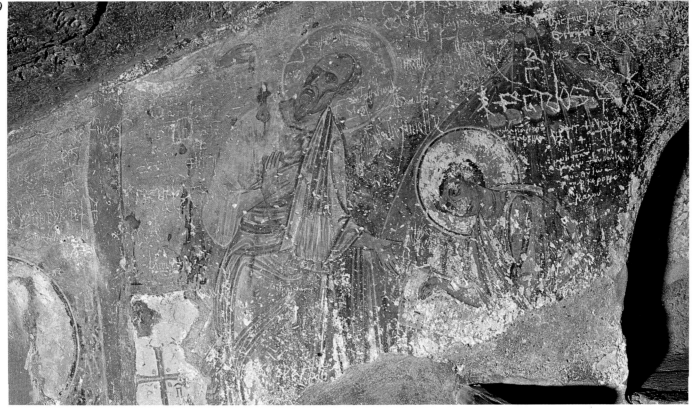

39. Cave of the Apocalypse. St. John the Theologian dictating to Prochoros (two layers).

dered less harshly and in a more naturalistic manner. The former is closer to the Hierarchs in the Chapel of the Holy Virgin and those of the first painting layer in the Refectory. The latter has no parallel in the murals of Patmos, but is rather reminiscent of figures in the church of St. Demetrios at Vladimir and at Bačkovo in Bulgaria. The contrast described above does not necessarily imply that two different painters had worked here. It may well be that the same artist had been influenced by two different models. The resemblance of these two figures with the paintings in the Chapel of the Holy Virgin and in the Refectory of the Monastery of Patmos, and their affinity with the murals in St. Demetrios at Vladimir and at Bačkovo, strongly suggest that these paintings were also made around the last two decades of the 12th century.

The wall paintings of Patmos are of a high standard revealing the hand of experienced and established artists of a major centre of the Byzantine Empire. Constantinople is the most likely place of origin of these ateliers, since the Monastery of Patmos is known to have been given special protection and support by the emperors of Byzantium. Besides, there was a direct link between the monastery and the Capital. The abbots of the monastery paid frequent visits to Con-

stantinople, to request or confirm privileges and receive financial support. The Capital was also the place of residence of Leontios, Patriarch of Jerusalem, the most probable donor of the wall paintings in the Chapel of the Holy Virgin.

The Monastery of Patmos does not seem to have preserved any portable icons painted by the distinguished artists who worked in the late 12th and in the 13th century for the mural decoration of the Chapel of the Holy Virgin, the Refectory and the Cave of the Apocalypse. Nevertheless, four icons have survived from that age: St. John the Theologian (Fig. 42) —the main devotional icon of the monastery — a large 12th century icon painted over in the 15th century; St. Theodoros Tiro (Fig. 41), dated to circa 1200; and St. James the Brother of Christ (Fig. 40), painted about 1260-1270. The style and quality of these three works disclose once again the dependence of the Monastery of Patmos on Constantinopolitan art in that age. The fourth one is the 11th century mosaic icon of St. Nicholas (Fig. 43), probably brought from Asia Minor by Hosios Christodoulos himself.

Elias Kollias

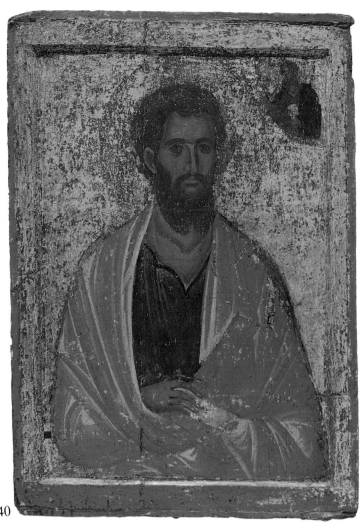

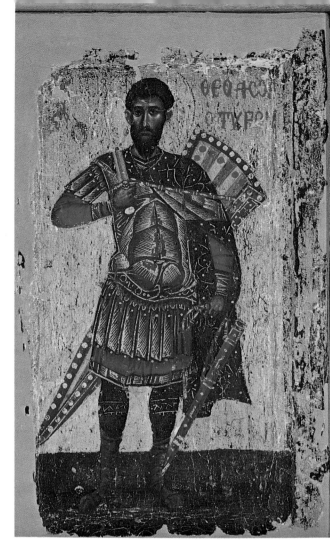

40

41

42

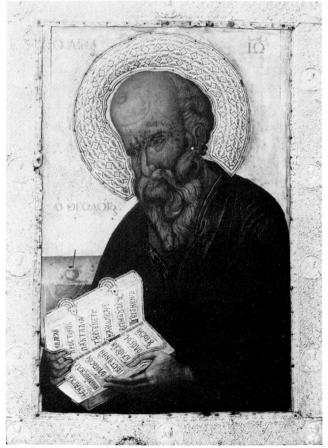

40. St. James the Brother of Christ. Portable icon of the 13th century.

41. St. Theodoros Tiro. Portable icon of the 12th century.

42. St. John the Theologian. Portable icon of the 12th century (painted over).

43. St. Nicholas. Mosaic icon of the 11th century.

43

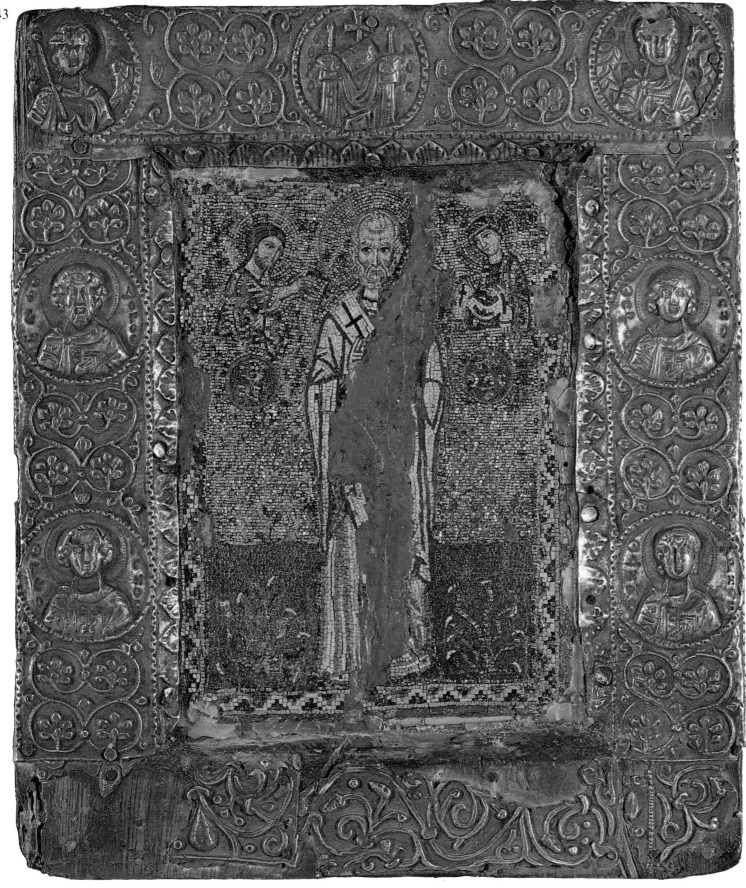

The colour illustrations of PATMOS present a chromatic dissimilarity, because of the different state of the wall paintings. Colour plates with bright colours show the wall paintings immediately after their cleaning (in about 1960). These photographs by M. Skiadaresis are taken from the archives of A. Orlandos, now kept in the Archaeological Society of Athens. Black and white prints are from the same archives. The other colour plates show the state of the wall paintings some twenty years later. The difference is quite impressive. Regrettably, the illustration of the book could not be limited to one series only.

Thanks are due to the Archaeological Society of Athens.